OAk BROot, IL

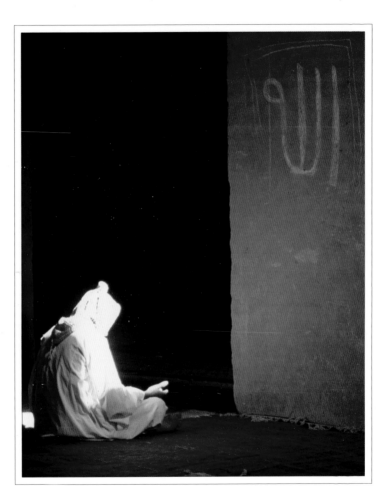

SUFISM

THE ALCHEMY OF THE HEART

EASTERN WISDOM

CHRONICLE BOOKS
SAN FRANCISCO

A Labyrinth Book

First published in the United States in 1993 by Chronicle Books.

Copyright © 1993 by Labyrinth Publishing (UK) Ltd.

Text copyright © 1993 by Dr. M. I. Waley

Design by Meringue Management

The Little Wisdom Library–Eastern Wisdom was produced by Labyrinth Publishing (UK) Ltd. Printed and bound in Singapore by Craft Print Pte. Ltd.

Library of Congress Cataloging in Publication Data: Sufism, Eastern Wisdom.

p. cm. (Eastern Wisdom) Includes bibliographical references.

ISBN 0–8118–0410–0:

1. Sufism. I. Chronicle Books (Firm) II. Series.

BP189.S784 1993

297. 4– – dc20 92–42264

CIP

Distributed in Canada by Raincoast Books,

112 East Third Avenue, Vancouver, B.C. V5T 1C8

10 9 8 7 6 5 4 3 2 1

Chronicle Books

275 Fifth Street, San Francisco, CA 94103

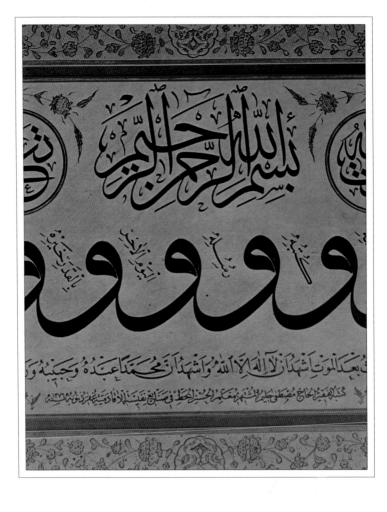

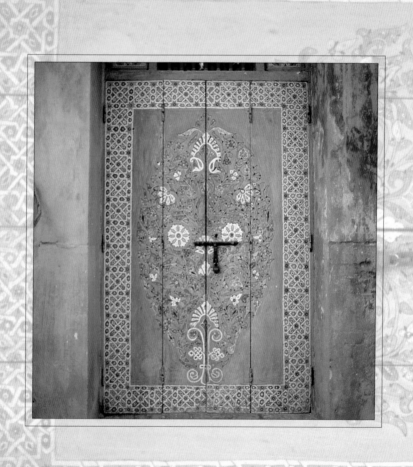

Introduction

Sufism is the mysticism of Islam and forms part of that faith. The Sufis' goal, however, is first to strengthen faith and then to transcend it by gaining, through Divine Grace, a love and a certainty that spring from direct knowledge of God. Sufis identify their Path with the pursuit of excellence or *iḥsān* as defined by the Prophet Muhammad, peace and blessings be upon him: "Excellence is that you worship God as though you saw Him; and if you do not see Him, still He sees you."

Today, Sufism is the object of widespread interest and curiosity among non-Muslims. In part, this interest is due to the accessibility and appeal of its inward aspects. But like some other Eastern spiritual traditions its outward forms as well have particular appeal for

Westerners. For example, the culture and disciplines of Zen have attracted far wider interest in the West than

and culture of extraordinary beauty and vigor that live on today. Its symbolism speaks to the heart and mind in poetry, discourses, music, and art. Above all, though, it is the integral human being, who embodies the Sufi Way, from whom we may learn about a living spirituality.

Faith in the doctrines of Unity forms a bulwark against the alienation and fragmentation of the soul so characteristic of "advanced" societies. In other ways, too, Sufism seems to answer the needs of a growing number of seekers after Truth. Many of them are "born Muslims" in search of a basis on which to rebuild their personal attachment to Islam. The problems inherent in modernization and "development" have weakened knowledge of the Scripture, Law, and ethics of Islam as well as of every other

those of mainstream Mahayana (let alone Hinayana) Buddhism. The Path of Sufism too has produced a literature

traditional science, from medicine to music. Innumerable Sufis are happy to choose poverty in accordance with the example of the Prophet, who taught that true wealth consists in contentment with what one has, and true poverty in discontent. While Sufism cannot cure all of society's ills, it offers compensations. Its doctrines serve to support the principles and ethics of Islam with proofs satisfying to heart and to mind. The brotherhoods provide shelter, networks of contacts, and social and spiritual support, as was shown by their role in sustaining Islam in Central Asia, Caucasia, and elsewhere in the Communist era. Today,

the structure of authority within the Orders remains largely intact.

Hundreds of works have been written on Sufism. Words cannot fully encompass our everyday feelings, far less the realities of the World of the Spirit. But the teachings of the Sufi Masters offer counsel and inspiration to any reader with an open mind. The aim of this little book is to outline and illustrate with quotations just a few features of Sufism.

Dr. M. I. Waley,
Curator of Persian and Turkish
Manuscripts and Books
British Library, London

Previous pages 10–11: Pages from the Koran, Persia, c. 1550. *Right:* Calligraphy is used as a meditative art form and as an expression of devotion.

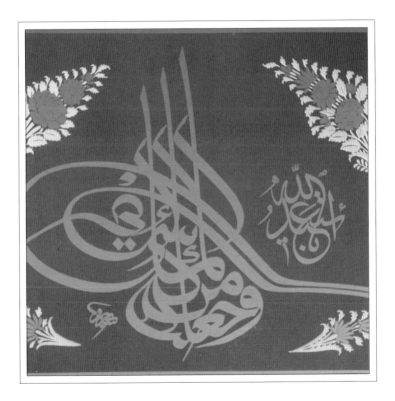

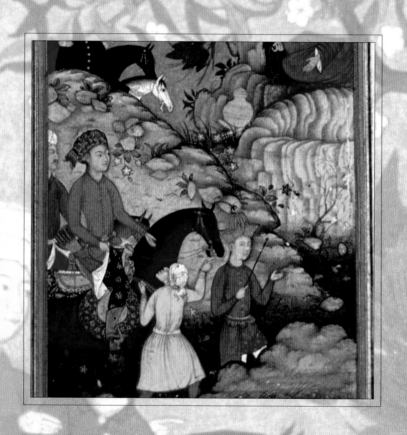

The Origins & Nature
Of Sufism

Today, as through the centuries, Sufism is surrounded by misunderstanding and controversy. For many non-Muslims, the word "Sufi" or "dervish" conjures up an exotically bizarre image: snake charmers, perhaps, or "fakirs" walking on hot coals. Or it conjures up nightmarish crazed fanatics brandishing scimitars. In certain countries, too, Sufism is disapproved of as challenging the "official Islam" approved and propagated by the state—or else as being dangerously fatalistic.

"Although the development of *Tasawwuf* [Sufism] can be historically compared with that of the other sciences, there is an intrinsic superiority in *Tasawwuf* which should be well remembered.

This superiority lies in that the expansion of the science of spiritual development is based on experience and direct observation confirmed in its broad pattern by thousands of travellers on the upward path of the soul" (Shahidullah Faridi, an English Shaykh, 1915–1978, *Inner Aspects of Faith*).

Though indebted to other sources

Above: The central decorative pattern from a hand–woven wool carpet. *Right:* One of the derivations of the word *Tasawwuf* (Sufism) is the Arabic word *suf,* meaning "wool," because the mystics of Islam wore hand-woven woolen garments

for certain details and terminology, Sufism has its origins in Islam.

Derived from the Arabic word *Tasawwuf*, Sufism has been linked to the *Suffa*, or veranda, of the Mosque of the Prophet in Medina, home of several of his greatest Companions; to the Arabic words *sūf* ("wool"), traditionally worn by the mystics of Islam; to *sāfa'* ("purity"); and to the Greek *sophos* ("wisdom"). Each of these derivations indicate important aspects of what Sufism is.

As a scientific and spiritual Way of self-purification and self-realization, Sufism represents the initiatic Path or *Tariqa* and inner Reality, *Ḥaqiqa*, of Islam, which complements the Law, *Sharī'a*, and deepens awareness of its

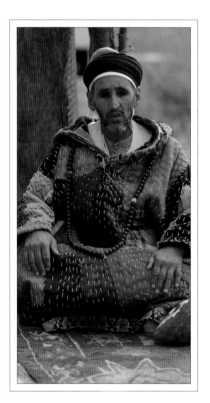

profound understanding without contradicting it. Sufism existed as a reality for centuries before the word did. Much of its core doctrine and practice is found in the basic sources of Islam: the Holy Koran and the canonical Traditions, or *Ḥadīths*, that record the acts and sayings of the Blessed Prophet.

One of the first Divine Commands revealed to the Prophet Muhammad was "Invoke (or remember) The Name of your Lord, and devote yourself to Him with complete devotion" (Koran LXXIII, 8). This Revelation sanctions, indeed demands, the practice, central to Sufism, of invocation of God.

Above: The Holy scriptures are still used as inspiration for religious, meditative art.
Right: Woman in prayer.

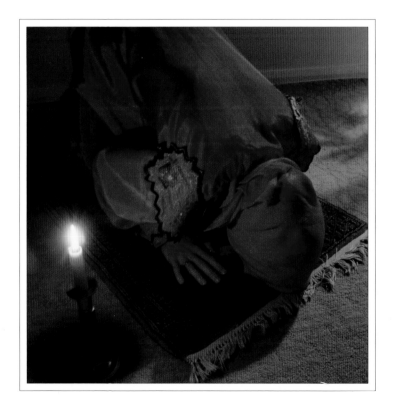

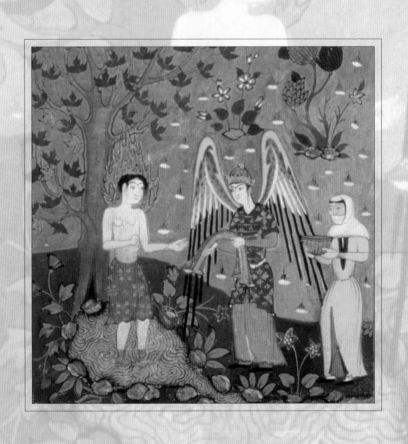

The Essence
Of Sufism

"Recline on the throne of the heart, and with purity in manner be a sufi."
(Sa'dī)

he central doctrine of Sufism is that of Divine Unity. In theological terms, this means first and foremost that there can only be one God: *Lā ilāha illā 'Llāh*, meaning there is no god but God, who is One. The practice of Sufism is the seeking of the Truth through love and devotion to God; to follow the Spiritual Path, the way towards God. A Sufi is a lover of Truth, of the Perfection of the Absolute. As the great Sufi mystic Jalāl al-Dīn Rūmī illustrates with his story of the elephant in the dark, the Truth can only be seen in the light of the Spiritual Path; in its entirety rather than as one component of the whole.

REMEMBRANCE
OF GOD

"Never be without remembrance of Him, for His remembrance gives strength and wings to the bird of the Spirit. If that objective of yours is fully realized, that is 'Light upon Light.'...

"An elephant belonging to a traveling exhibition had been stabled near a town where no elephant had been seen before. Four curious citizens, hearing of the hidden wonder, went to see if they could get a preview of it. When they arrived at the stable they found that there was no light. The investigation therefore had to be carried out in the dark. One, touching its trunk, thought that the creature must resemble a hosepipe; the second felt an ear and concluded it

was a fan. The third, feeling a leg, could liken it only to a living pillar; and when the fourth put his hand on its back he was convinced that it was some kind of throne. None could form the complete picture; and of the part which each felt, he could only refer to it in terms of things which he already knew. The result of the expedition was confusion." Like the elephant, existence, according to Sufi cosmology, is like an unimaginably vast tapestry woven from the Divine Qualities. Only by distancing ourselves from the surface immediately before us can we hope to find its meaning—and our own place in the tapestry. Each moment God manifests Himself to, and in, Creation.

> ...But at the very least, by practicing God's remembrance your inner being will be illumined little by little and you will achieve some measure of detachment from the world."
>
> (Jalāl al-Dīn Rūmī, *Fīh mā fīh*)

As the Prophet Muhammad said, "What God first created was my Light." In order to see the Truth, a Sufi must see with his inner being, in harmony with the Divine Nature. Through devotion to and selfless remembrance of God, *dhikr Allāh*, the Sufi disciple's attention to the self falls away, and in turning to God, his heart and soul are transformed by the Divine Attributes. In this spiritual state of the self-having-passed-away-in-God, or *fanā'*, a Sufi existentially realizes the Truth. This Divine Unity is the aim of Sufism.

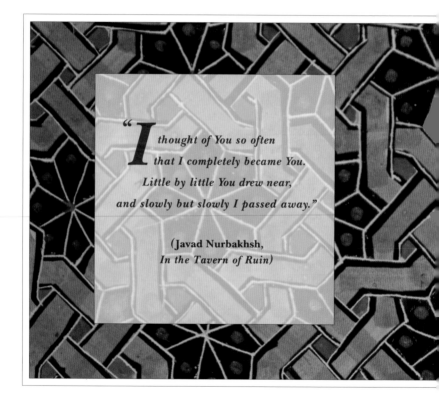

"*I* *thought of You so often*
that I completely became You.
Little by little You drew near,
and slowly but slowly I passed away."

(Javad Nurbakhsh,
In the Tavern of Ruin)

"Kill me, o my trusty friends,
for in my killing is my life,
My life is in my death, and my
death is in my life."
(Ḥusayn ibn Mansūr al-
Ḥallāj, *Diwan*)

The Prophets and, sup-
reme among them, Muh-
ammad are manifestations
of Divine Unity and incar-
nations of the Divine
Attributes. Divine Unity
has profound aspects which are cen-
tral to the Sufis' understanding of
the nature and structure of Truth,
Reality. This brings us to symbolism—
the basis of Scripture and of all art in
the proper sense—and to metaphysics.

REALITY AND TRUTH
"Everything engendered
in existence is
Imagination—but in fact it
is Reality. Whoever
understands this truth
has grasped the mysteries
of the Way."
(Ibn 'Arabi, *Fusūs*
*al-ḥikam***)**

The metaphysics of Sufism
is based largely upon inter-
pretation of the Holy Koran
and the teachings of the
Prophet, reinforced by
direct experience. The
teaching is that Allāh is one
of many Divine Names, all
of which reflect aspects of
Reality. In His Essence, God
is beyond all description
and imagination. The
Divine Attributes are the
source of all existent beings, and of all
events: as the Koran explains, "God is
the Creator of you and all that you do"
(Koran, XXXVII,96). The Divine
Names or Attributes are invoked in
prayer and are commented upon in

Previous pages 24-25: An example of an
intricate pattern on a hand-painted ceiling.
Right: A Moroccan Sufi.

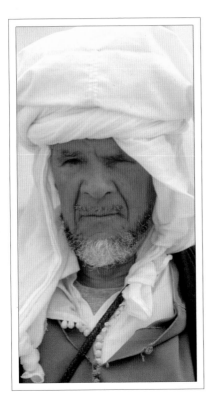

Sufi treatises. A number of the Names can be classified as names of Majesty (*Jalāl*) or of Beauty (*Jamāl*). For example, God is the Life-Giver, the Exalter, the All-Merciful; He is the Slayer, the Abaser, the Perfectly Just, all at the same time. All that befalls us, whether experienced as beneficial or as harmful, as pleasurable or as painful, comes from God; to submit to God—to Reality—is to base one's life upon trust that Reality means us good, not ill.

The Divine Promise states that human perfection is attainable through a total purification of the attributes of the lower soul which enables the Divine Attributes to take their place. Such a transformation cannot, however, be realized without the help of a specialist,

a physician and trainer of hearts and souls. This is the province of Sufism. Sufism has been described as the alchemy of the human heart, an alchemy that works through three aspects: action, love, and knowledge. All three are essential elements of the spiritual Path.

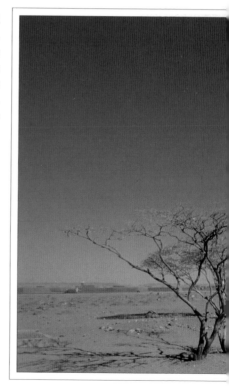

Opposite: A solitary tomb stands in the desert land of the Prophet.

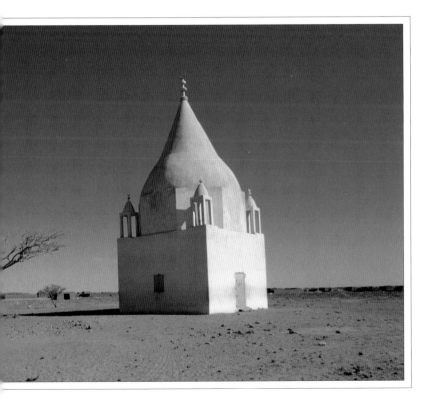

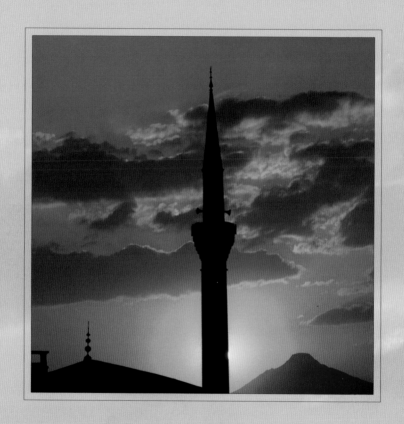

From Man To God:
The Path & Its
Methodology

Tasawwuf, is regarded by Sufis as a science: a medicine of the soul, an alchemy of the heart. A Sufi disciple, to achieve Divine Unity, must have a guide through this world, a master or Shaykh who is one with the Beloved. There are many different Sufi groups or Orders today, as for centuries past. Each Order has a spiritual chain of authority, a framework of rules of discipline, and distinct spiritual practices. While the emphases in the teachings of Sufi Orders may differ, they have much in common and all follow the spiritual personality of the Prophet Muhammad, as well as the Prophet's beloved cousin and son-in-law 'Alī, to whom almost all lines of initiatic blessing in Sufism are traced.

The purification of the soul is vital to progress on the Sufi Path. It is imperative to go beyond "do as you would be done by," by sacrificing one's own interest

Page 30: A minaret set against the sunset in the land of the Sufi. *This page:* A hand-painted design on the wall of a house.

for that of others. Disciples may be required, if the Master deems it necessary, to undertake the actions which they most dread: this is both a trial of sincerity and an effective means of overcoming the instincts of the ego. "What is false is veiled by the veil of the ego and what is true by the veil of the Heart. The veil of the ego is a dark, earthly veil, while the veil of the Heart is a radiant, heavenly veil." ('Umar al-Suhrawardī, *'Awārif al-ma'ārif*)

In training the *nafs* or ego, disciples are required to keep watch methodically on their own behavior. This self-assess-

> **UNREAL AND REAL**
>
> "God made the creatures as veils. He who knows them to be such is led back to Him, but he who takes them as real is barred from His Presence."
>
> (Muhyī 'l-Dīn Ibn 'Arabī, *al-Futūhāt al-Makkiyya*)

ment, or *muhāsaba*, is one in which all one's intentions are scrutinized as to their sincerity, and one's actions and words as to their correctness. Believers also develop in the practice of meditation: reflecting upon, and learning from, manifestations of the Divine in things around one and in daily events. Although all phenomena are veils between God and Man, they are also signs and symbols. At all levels of Being, they point—for those endowed with insight —towards the One True Reality. "And whoever is granted wisdom is granted much goodness" (Koran: II, 269).

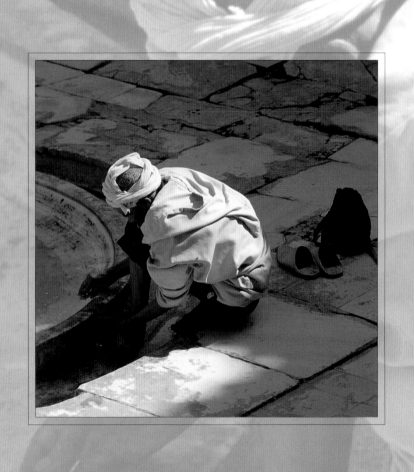

Concentration On The Goal

"If you wish what you need to be given to you without your having to search for it, turn away from it and concentrate on your Lord; you will receive it if God wills. And if you gave up your needs entirely and were occupied only with God, He would give you all the good things you wish for in this world and the other; you would walk in Heaven as well as on the earth; and more than that, since the Prophet (on him be blessings and peace) has said, in the very words of his Lord: 'He who by remembering Me is distracted from his petition will receive more than those who ask'" (al-'Arabī al Darqāwī, *Rasā'il*).

Page 34: Prior to entering a mosque, the devout Muslim is required to wash his feet and leave his shoes behind at the entrance. *This page:* Patterns from a handwoven woolen carpet.

"*Material difficulties and worldly involvements can be resolved through close contact with one's fellow dervishes. This service to one another is the essential basis of all fraternity. In addition, the elimination of such difficulties leaves one more free time for resolving spiritual problems.*

Through associating with one's fellow dervishes, a greater intimacy is promoted among all the members of the Khāniqāh (meeting-place of the Order). From the other dervishes, one acquires the proper manners and behavior of sufis, and thus the qualities of perfection."

(**Javad Nurbakhsh**, *In the Tavern of Ruin*)

The Sufi Masters have classified the "stations" (*maqāmāt*) or "stages" (*manāzil*) of the Path, through which each seeker must pass on the Way to perfection; such stations must be traversed by the seeker before the goal of Realization is attained. Often the stages are linked to the acquisition of particular virtues or powers of subtle perception.

Above and opposite: The decorated border of a hand–woven wool carpet. *Page 39:* An enlarged detail of the same pattern.

*A*mong the supreme literary expositions of the stages of the Way is "The Discourse of the Birds," 'Mantiq al-tayr.' This Persian allegorical poem by 'Attār describes how a group of birds (representing souls of various human types) traverse seven immense valleys on their journey to the Simurgh, the mythical bird which here represents the Supreme Being. The valleys are named by the poet as those of the Quest, Love, Understanding, Detachment, Unity, Bewilderment, and Extinction. On finding and contemplating the beautiful and majestic Simurgh the birds achieve their essential and eternal life and identity by annihilating their individual selves in Him. Annihilation, or Extinction in God or al-fanā' fi 'Llāh, is followed by the Divine Gift of Eternal Being through God (al-baqā' bi-'Llāh).

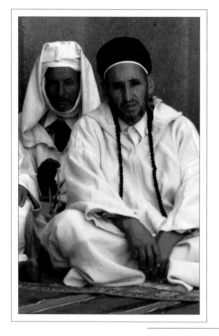

An important feature of most Sufi Orders is the recitation, either individually or collectively, of *awrād* or litanies. These generally consist of prayers, or *ṣalāt*, and doctrinal formulae derived from the Holy Koran, and are spoken at regular meetings for communal performance of worship and the rites and practices of the Order. In retreat or *khalwa*, the Shaykh puts the disciple into solitary confinement for a period of days to practice fasting and intensive *dhikr*. Experiences and visions are opened up for seekers during *khalwa*; the power of Love and of invocation open up the Heart to celestial influences and direct witnessing of the Unseen (*al-Ghayb*): the world beyond the senses.

Above: Two brothers sit together in preparation for prayer. *Opposite:* Sufi art combines color, grace, and religious inspiration.

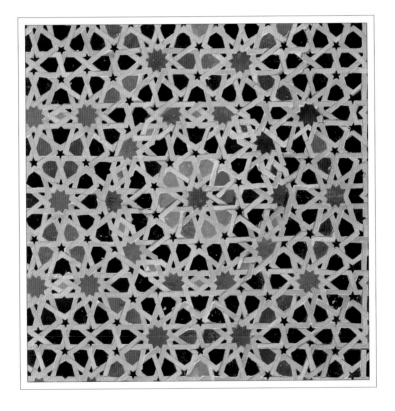

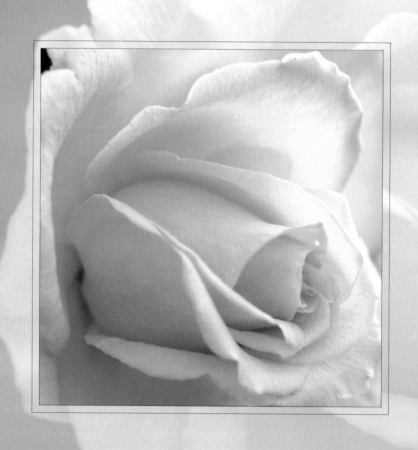

=

The Pure Heart: Divine Love & Gnosis

=

*"The Beloved sat facing my open heart
for so long that,
but for Her Attributes and Nature,
nothing remained of my heart."*
(Maghribī)

Once the mind has been trained, as it learns to focus upon the sacred, the heart follows. This brings the fruit of sincere love—for God, His Prophet, the Master, fellow-members of the Order, and for humanity in general.

A Sufi in love loses himself and finds himself in the love of God. This all-consuming love is illustrated by Rūmī in the story of the lover at the door of his Beloved:

Page 42: The rose is a symbol of the pure Heart. *This page:* Prayer beads.

"One went to the door of the Beloved and knocked. A voice asked, 'Who is there?'

He answered, 'It is I.'

The voice said, 'There is no room for Me and Thee.'

The door was shut.

After a year of solitude and deprivation he returned and knocked. A voice from within asked, 'Who is there?'

The man said, 'It is Thee.'

The door was opened for him."

(Jalāl al-Dīn Rūmī)

A vital doctrine of Sufism concerns the Heart, which represents for the spiritual being of every human what the physical heart repre-

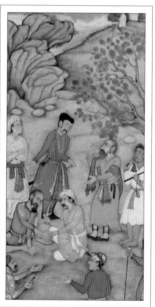

sents for the body. God has made the Heart as a mirror capable of reflecting the Light of God and His Attributes. In the words of a Sacred Tradition, "Neither My Earth neither My Heaven can contain Me; but the heart of My believing Servant contains Me." Knowledge of the Heart, combined with love of God, brings

an immediacy and vividness that instills lasting certainty.

God is veiled by His manifestations—by the tangible phenomena of the world of the senses—and our Hearts too are veiled from us by worldly desires and illusions.

"From the terrestrial to the celestial domain all veils are torn For he who serves the goblet which shows the Universe." (Ḥāfiẓ)

"*Once you have been filled with the Wine Everlasting*
you'll not see the goblet, just smell its perfume.
All inanimate beings will give you their greetings
and tell you their secrets, like friends and relations.
Once the Spirit Supreme has embraced you in Love
all forms turn to spirits before your eyes.
The time has come for me to dance in a circle;
with face unveiled, Love is singing love-poems.
Like the red rose, Love goes out for a ride;
all the sweet herbs follow behind, like troops.
Bring sweetmeats and wine and sit before me,
you whose face is a candle, whose wine is like fire!"

(Jalāl al-Dīn Rūmī, *Dīwān-i Kabīr*)

Such is the human condition in our worldly exile from the Paradise where we belong, and the Prophet Muhammad said: "Everything needs a kind of polish to cleanse it, and the polish for the Heart is the remembrance of God." The aim of Sufis is to establish the recollection and direct awareness of God in the Heart as perpetual.

Previous pages, 46 and 47 (background image in box): Drawings of animal fables from a moghul manuscript in Persian from the early seventeenth century. *Opposite:* Another example of religiously inspired art.

Samā': The Enraptured Dance

No account of Sufism would be complete without mention of *samā'*—spiritual music, singing, and dancing. The best-known form of *samā'* is that of the so-called "Whirling Dervishes" of the Mevlevi Order named after the great saint and poet Mawlānā Jalāl al-Dīn Rūmī. To the ethereal music of the *nay* or flute, the dervishes spin in intense spiritual concentration, with one hand outstretched towards the heaven to receive blessings and the other turned towards the earth to transmit them.

Previous pages: Wood–carving on an entrance door.
Opposite: The "Whirling Dervishes" of the Mevlevi Order enact one of the most awe–inspiring forms of religious devotion..

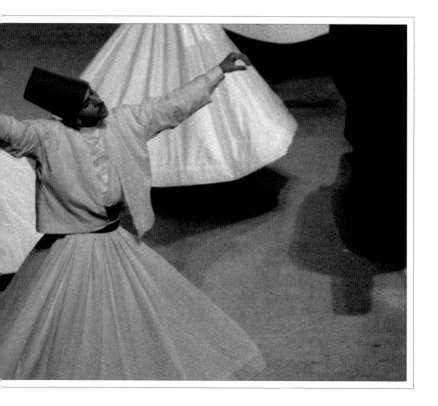

"*Music does not produce in the Heart anything which is not already there. Music arouses sensual desire in one whose inner self is attached to something other than God; but one who is inwardly attached to the love of God is moved, by hearing music, to do His will.*"

('Umar al-Suhrawardī,
'Awārif al-ma'ārif)

In *samā'*, the Sufi is spiritually enraptured in the remembrance of God, listening to the "call of God." When this love for God strikes the heart of the Sufi, his inner being is moved. The spiritual music of *samā'* transports him from himself to a state where he senses in his heart the awesome, all-absorbing presence of God.

"*RŪMĪ HAS SAID:*

Dance where you can break yourself to pieces and totally abandon your worldly passions.
Real men dance and whirl on the battlefield;
they dance in their own blood.
When they give themselves up, they clap their hands.
When they leave behind the imperfections of the self, they dance.
Their minstrels play music from within;
and whole oceans of passion, foam on the crest of their waves."

"RUZBIHAN HAS ALSO SAID:

*Shorn of the worldly desires and passions of
the self, disciples of Love hear Samā'.
Cut off from their own minds,
seekers yearning for God hear Samā'.
Deprived of their hearts,
those enamored of Love hear Samā'.
Those who have gone beyond even their spirit,
who are totally lost in nearness to God, hear Samā'.
If, on the contrary, hearing is with the worldly self,
mind, heart, or spirit,
Then one is still veiled from God."*

The primary effect of *samā'* is to produce in the participant a "state" (Arabic *ḥāl*). "States" are particular transitory graces which manifest themselves in the heart at particular moments through Divine intervention. "And know that God intervenes between a man and his Heart, and that you shall all be gathered back to Him" (Koran:VIII, 34). Such experiences are scarcely describable, but the literature of Sufism abounds in beautiful passages that do convey something of the magic and blessing of such passing moments.

Sufism continues to answer the needs of a growing number of seekers after Truth. The beauty, richness, and sheer exoticism of Sufi imagery, art, and imaginative literature, and the holistic world-view and philosophy of Sufism, have brought into the world some of the most exquisite and profound expressions of the World of the Spirit. Today as ever *Tasawwuf* is a living form of guidance.

BIBLIOGRAPHY

al-Darqāwī, al-'Arabī, *Letters of a Sufi Master,* translated by Titus Burckhardt, Perennial Books, Middlesex, 1969

Faridi, Shahidullah, *Inner Aspects of Faith,* Madina Publishing Co., Karachi, Pakistan

Idries Shah, Sayyid, *The Sufis,* introduction by Robert Graves, Doubleday & Co., New York, 1964

Nurbakhsh, Javad, *In the Tavern of Ruin - Seven Essays on Sufism,* Khaniqahi-Nimatullahi Publications, London, 1978

Schimmel, Annemarie, *Mystical Dimensions of Islam,* University of North Carolina Press, Chapel Hill, 1975

'Attār, Farīd al-Dīn, *The Conference of the Birds.* Abridged translation by C.S. Nott, Janus Press, London, 1954; reprinted by Routledge & Kegan Paul, 1961

Bakhtiar, Laleh, *Sufi Expressions of the Mystic Quest,* Thames and Hudson, New York and London, 1976

Chittick, William C., *The Sufi Path of Love: The Spiritual Teachings of Rumi,* State University of New York Press, Albany, 1983

al-Ḥaddād, Ḥabīb Ahmad Mashhūr, *The Key to the Garden.* Translated by M. al-Badawi, Quilliam Press, London, 1990

Ibn 'Arabī, Muḥyi 'l-Dīn, *Sufis of Andalusia.* Translated by R.W. Austin, Allen & Unwin, London, and University of California Press, Berkeley, 1971

Ibn 'Aṭā' Allāh, *The Book of Wisdom.* Translated by V. Danner. Together with *Intimate Conversations* by Khwaja 'Abd Allāh Ansārī, Translated by W. M. Thackston, Paulist Press, 1978, and SPCK, London, 1979

Kalābādhī, Abū Bakr, *The Doctrines of the Sufis.* Translated by A.J. Arberry, Cambridge University Press, Cambridge, 1935; reprinted S.M. Ashraf, Lahore, 1966

Lings, Martin, *A Sufi Saint of the Twentieth Century: Shaikh Aḥmad al-'Alawī,* Allen & Unwin, London, and University of California Press, Berkeley, 1975

Nasr, Seyyed Hossein, *Sufi Essays,* Allen & Unwin, London, 1972

editor, *Islamic Spirituality I: Foundations,* Routledge & Kegan Paul, London, 1987

editor, *Islamic Spirituality II: Manifestations,* Routledge & Kegan Paul, London, 1987

Nicholson, R.A., *Rumi, Poet and Mystic,* Allen & Unwin, London, 1950

The Mystics of Islam, Routledge and Kegan Paul Ltd., London, 1963

Rāzī, Najm al-Dīn Dāya, *The Path of God's Bondsmen, from Origin to Return.* Translated by H. Algar, Caravan, Delmar, N.Y., 1982

Schimmel, Annemarie, *As Through a Veil - Mystical Poetry in Islam,* Columbia University Press, New York, 1982

Shabistarī, Maḥmūd, *Gulshan i raz: The Mystic Rose Garden.* Edited and translated by E.H. Whinfield, Truebner, London, 1880

ACKNOWLEDGMENTS

While every effort has been made to trace all present copyright holders of the material in this book, whether companies or individuals, any unintentional omission is hereby apologized for in advance and we will be pleased to correct any errors in acknowledgments in any future edition of this book.

Text acknowledgments:

p. 16 — Faridi, Shahidullah, *Inner Aspects of Faith*, Madina Publishing Co., Karachi, Pakistan. Reproduced by kind permission of the publisher.

p. 22-23 — Idries Shah, Sayyid, *The Sufis*, Introduction by Robert Graves, Doubleday & Co. Inc., New York, 1964. Reproduced by kind permission of the publisher.

p. 36 — al-Darqāwī, āl-'Arabī, al-Darqāwī, *Letters of a Sufi Master*, translated by Titus Burckhardt, Perennial Books, Middlesex, 1969. Reproduced by kind permission of Mrs. O. Clive-Ross.

Sidebar on p. 37 — Nurbakhsh, Dr. Javad, *In the Tavern of Ruin - Seven Essays on Sufism*, London, Khaniqahi-Nimatullahi Publications, 1978, 2nd edition. Reproduced by kind permission of the publisher.

p. 45 — Idries Shah, *op. cit.*

p. 55 — Nurbakhsh, *op. cit.*

p. 56 — Nurbakhsh, *op. cit.*

The publishers wish to thank Dr. Waley for his patience, dedication, and thoroughness in the preparation of the present work, and for contributing his own translations to the passages that appear on pp. 22-23 ("Remembrance of God") and p. 47.

Picture acknowledgments:

Peter Sanders Photography; Pages: 4, 7, 8, 13, 17, 18, 19, 24, 25, 27, 28, 29, 30, 32, 34, 40, 41, 42, 44, 45, 48, 49, 50, 52, 53, 55, 56.
Christies Images; Pages: 10, 11, 16, 36, 37, 38.
British Library; Pages: 14, 20, 46, 47, 58.
Ancient Art & Architecture; Page: 54.
Geoff Howard, Sufi Master; Page: 57

Jacket: *Peter Sanders, Ancient Art & Architecture, Christies Images, British Library.*